50 GE[ms]

North Devon

DENISE HOLTON & ELIZABETH J. HAMMETT

AMBERLEY

First published 2019

Amberley Publishing
The Hill, Stroud
Gloucestershire, GL5 4EP

www.amberley-books.com

Copyright © Denise Holton & Elizabeth J. Hammett, 2019

Map contains Ordnance Survey data © Crown copyright and database right [2019]

The right of Denise Holton & Elizabeth J. Hammett to be identified as the Authors
of this work has been asserted in accordance with the
Copyrights, Designs and Patents Act 1988.

All rights reserved. No part of this book may be reprinted
or reproduced or utilised in any form or by any electronic,
mechanical or other means, now known or hereafter invented,
including photocopying and recording, or in any information
storage or retrieval system, without the permission in writing
from the Publishers.

British Library Cataloguing in Publication Data.
A catalogue record for this book is available from the British Library.

ISBN 978 1 4456 7959 4 (paperback)
ISBN 978 1 4456 7960 0 (ebook)

Typesetting by Aura Technology and Software Services, India.
Printed in Great Britain.

Contents

Map 4
Introduction 5

Ilfracombe and the Coast 6
1. Lynton and Lynmouth Cliff Railway 6
2. Watersmeet 7
3. Valley of the Rocks 9
4. Woody Bay Steam Railway 10
5. The Tunnels, Ilfracombe 12
6. Chambercombe Manor, Ilfracombe 13
7. Combe Martin 15
8. Woolacombe 17
9. Croyde 19
10. St Brannock's Church, Braunton 20
11. The Great Field, Braunton 22
12. Braunton Burrows 23

Barnstaple and Around 25
13. Penrose Almshouses, Litchdon Street, Barnstaple 25
14. Pannier Market, Barnstaple 26
15. St Anne's Chapel, Barnstaple 28
16. Ceiling at the Bank, No. 62 Boutport Street, Barnstaple 30
17. Queen Anne's Walk, Barnstaple 31
18. Pilton Church, Barnstaple 33
19. Green Man Festival, Pilton, Barnstaple 35
20. Marwood Hill Gardens 36
21. Arlington Court 38
22. Tawstock Church 40
23. Bishops Tawton and Codden Hill 43
24. Hall, Bishops Tawton 45
25. Tarka Line 47

South Molton and Around 49
26. South Molton 49
27. North Devon Show, Umberleigh 51
28. Castle Hill, Filleigh 53
29. Chittlehampton Church 55
30. Eggesford Forest 57
31. Tarka Trail 58
32. Torrington Common 61
33. RHS Rosemoor, Torrington 62
34. Dartington Crystal, Torrington 65

Bideford and Around 67
35. Fremington Quay 67
36. Bideford Bridge 69
37. The Quay, Bideford 70
38. Appledore 71
39. Instow 73
40. Tapeley Court 75
41. Westward Ho! 77
42. Weare Giffard 79
43. Frithelstock Church and Ruins of the Priory 81
44. Clovelly 82
45. Clovelly Dykes 85
46. Embury Beacon 86
47. Hartland Quay and Stoke Church 87
48. Hartland Abbey 89
49. Lundy 91
50. South West Coast Path 93

Bibliography 96

Introduction

The north of Devon is not well known. South Devon has the more famous holiday destinations. So it might be wondered if North Devon has sufficient of interest to merit a book of its own, but in fact there are many and varied attractions worth highlighting. There are rolling hills, sandy beaches, spectacular cliffs, magnificent sea views, and country estates with historic houses and glorious gardens.

It is not a wild landscape, but one that is the result of centuries and even millennia of cultivation. However picturesque they seem to us now, the winding lanes, the abundant hedges, and the limekilns around the coast are all the result of the history of this part of the world. There is a lot of history here. Both the chief towns of Barnstaple and Bideford were ports in the days when imported goods came by sea and river in return for the export of local products, mainly woollen goods and pottery. Pilgrims, emigrants, soldiers, adventurers and explorers all sailed from these ports, helping to discover and populate the New World. Seventeenth-century pottery from North Devon is found in the old settlements in Virginia and Maryland. Richard Grenville led expeditions to Virginia from Bideford; John Delbridge of Barnstaple was one of the founders of Bermuda. During the Civil War of the mid-seventeenth century Barnstaple changed hands four times, and the last significant battle was at Torrington in 1646. Every village has its church with monuments and memorials to the people who made North Devon what it is. Wherever you go in the area, there are likely to be reminders of the Chichester, Rolle and Fortescue families, who played a major part in the life of the area for centuries. Inland the main occupation was farming, and agriculture is still important. In coastal areas it was fishing that provided a living. North Devon has a long and intricate coastline and the economy of many of the fishing villages is now dependent on tourism. The steep, cobbled street of Clovelly is the outstanding example of this modern development. Once famous for its herrings, its spectacular setting and unchanged appearance has made it a magnet for visitors. Lynmouth, Ilfracombe, Appledore and Instow are other examples, while the beaches of Woolacombe, Saunton and Croyde are brilliant for those wishing to swim or sunbathe.

North Devon is also a splendid place for walking, from gentle strolls to strenuous rambles. There are numerous walks around the coastline, many forming part of the South West Coast Path. The Tarka Trail, a cycling and walking route along the disused railway lines, also provides miles of paths, which have the advantage of being mostly flat. It is perhaps worth remembering that the scenery of North Devon is so varied and interesting partly because it is hilly, so walks can be steep. They can also be muddy, because it does rain here sometimes, which, of course, is necessary to make the grass so green. We hope this book will encourage you to explore this fascinating corner of Devon.

Ilfracombe and the Coast

1. Lynton and Lynmouth Cliff Railway

The nineteenth century was a great time of innovation and progress, where no problem seemed insurmountable, but rather a challenge to be overcome. One such place to see Victorian problem-solving and engineering at its best is the Lynton and Lynmouth Cliff Railway. Travelling between the two towns (still villages in the early nineteenth-century) had long been a problem for local residents. The high cliffs separating them were a major impediment to economic progress. Deliveries of foodstuffs, coal and all other essentials would have to come via the sea at Lynmouth, weather allowing, and then be carried up the steep hill to Lynton on packhorses and carts – a time-consuming process carried out in all weathers. The growing popularity of coastal tourism was also affected. From 1820 holidaymakers arriving at Lynmouth on the paddle steamers from Bristol or Swansea would find the only way of travelling further was to hire the available ponies, donkeys or carriages. However, the extremely steep gradients of the surrounding countryside meant the carts could only take a small number of people at a time and the strain the animals would be under in pulling them would mean they would have fairly short working lives.

Proposals for some sort of rail-based lift that would be able to carry both passengers and goods were first made in 1881. This scheme was to be powered by steam; however, plans for this idea proved impractical and were abandoned. It was to be another five years before George Croydon Marks (later Baron Marks of Woolwich) came up with his innovative water-powered railway design. His business partner, editor and publisher of *The Strand Magazine*, Sir George Newnes, paid most of the cost of the railway. Newnes owned a large residence at nearby Hollerday Hill and also backed the Lynton & Barnstaple Railway in 1898 and the unusual and ornate Lynton Town Hall in 1900. Construction work began in 1887 and due to the difficult and challenging terrain, had to rely entirely on manual labour.

When the railway was completed it rose 500 feet on 862 feet of steep track with a gradient of 57 per cent. The 700-gallon water tank on the top passenger car is filled with water from the West Lyn River. The water from the lower car is then emptied until the heavier top car descends, pulling the lower car up the steep incline of track. There is

Early coloured print of Lynton and Lynmouth Cliff Railway.

a driver in both passenger cars, with speed being controlled by each driver using a mechanism called the Deadman's Handle. This breaking apparatus was designed and patented especially for this railway in 1888 – the same year the Lynton and Lynmouth Lift Company was formed by an Act of Parliament – and is considered the forerunner of the modern train breaking system. Each car can hold up to forty people.

The Cliff Railway was opened on Easter Monday 1890 with another Act of Parliament giving the company 'perpetual rights to the water from the Lyn Valley'. Now classified as a Grade II listed monument, the working heritage railway is Britain's only fully water-powered railway and one of just three examples left in the world. Today the Cliff Railway is as popular as ever and the views are spectacular. The best place to experience the ride is to stand in the front balcony section, near the driver, and see the breathtaking view unfold before your eyes.

2. Watersmeet

The beautiful and dramatic Watersmeet on the North Devon coast is the meeting place of the East Lyn River and Hoar Oak Water. The site, now owned by the National Trust, covers some 40 miles of woodland and streams. One of the largest

ancient woodlands still remaining in the South West, the visitor will find oak woods, ash trees and wych elm, together with some quite rare species. The site also has a diverse breeding bird populace with redstarts, pied flycatchers, woodpeckers and ravens all regular visitors. It is the starting point for some of the most beautiful walks North Devon can offer, from short trails to longer hikes and the deep river gorge, one of Britain's deepest, has been described as one of the most dramatic valleys in the country. The valley gorge was created at the end of the Ice Age by the power of the melting ice coming off the glaciers and cutting through the sandstone, mudstone and Devonian rock of the coastal area. It was this geology that originally drew tourists to the site in the nineteenth century and many of the great Romantic poets came here. William Wordsworth, Samuel Taylor Coleridge, Robert Southey and Percy Bysshe Shelley all came and were captivated by the area, comparing Watersmeet with the Alps. It was at this time that it became known as 'Little Switzerland'.

Watersmeet House, on the east bank of the river, is a former fishing lodge designed and built by Revd Walter Halliday in 1832. It became a tea garden in 1901 and is today used as an information centre, tea room and shop. The National Trust has owned the house since 1996.

In recent years remains of two fortified farmsteads from the late Iron Age have been found at the site, together with evidence of animal enclosures. They would have been surrounded by ramparts and steep-sided hills.

Cascading waterfall at Watersmeet.

3. Valley of the Rocks

The rugged and mysterious Valley of the Rocks lies roughly halfway along the Exmoor coast and parallel to the North Devon coastline, just over a half mile to the west of Lynton. Formed by the melting glaciers at the end of the last Ice Age, the rocks are among the oldest Devonian geologic period (approximately 420 million years ago) in the region and are highly fossiliferous. This area was on the edge of the glaciation during this time, which has helped shape the landscape giving the stark natural beauty it has today. The steep cliff sides are covered by heather, bracken and gorse. On approaching the valley, the visitor is struck by the stunning and rugged beauty of the area and the spectacular view of the coastline. On a good day it is possible to see the Welsh coast. The whole valley area has some fabulous walks where visitors can enjoy the atmospheric scenery and see the feral goats clambering over the rocks with great agility.

The poet Robert Southey visited the valley in August 1799 and described it as, 'Covered with huge stones, the very bones and skeletons of the earth; rock reeling upon rock, stone piled upon stone, a huge terrific mass.' Seventy years later R. D. Blackmore set part of his novel *Lorna Doone* in the valley.

A prehistoric settlement is believed to have existed in the valley, but little evidence now remains. A field system is visible from aerial photographs and there are signs of two enclosures, but the site would require a complete clearance of bracken to be sure of what lies below. Nineteenth-century writers were fond of writing about

Looking out to sea at the Valley of the Rocks.

Above: Wild goats roam freely at the Valley of the Rocks.

Left: Dramatic scenery of the Valley of the Rocks.

'Druidical monuments and mysteries' and much myth and legend has built up over the centuries. Some early topographical prints exist that show a circle of stones at the foot of Castle Rock in the valley; however, if any megalithic monuments did exist, they were destroyed in the nineteenth century. In 1854, a Mr Charles Bailey of Ley wrote an open letter to the inhabitants of Lynton in which he reproached them for 'the removal of the immense Druidical stones, and circles ... for the purpose of selling them for gate-posts'.

4. Woody Bay Steam Railway

Woody Bay, 3 miles west of Lynton on the North Devon coast, sits at the edge of Exmoor. Originally part of the Lynton to Barnstaple railway line, today Woody Bay station is the boarding point for a short trip on the lovingly recreated narrow-gauge railway line in heritage steam trains. The restored track currently operates between Woody Bay station and Killington Lane Halt, a 2-mile round trip that, including stops, takes around twenty-five minutes in all. It's worth noting that the tickets are valid all day so visitors can travel on the line as many times as they wish. Operating from late March to early November, there are also some special Christmas trips to enjoy in December. It is a fantastic place for the train enthusiast watching the work of the staff as the carriages are manoeuvred into place and attached to the engines. The scenery from the train is beautiful as the countryside sweeps down to the sea in the distance.

Now owned and operated by a non-profit-making educational charity, and manned entirely by volunteers, the Barnstaple to Lynton line originally opened in 1898. Work had actually started three years earlier, but construction took longer and the cost was far higher than had been anticipated. Known as the L&B, it was often referred to as 'the Toy Railway' due to the overall height of a coach being only 8 feet 7 inches, when the average at this time was over 13 feet. The narrow-gauge track was chosen to lower the cost of construction, with the total length of the line being 19 miles.

Sadly, due to the increase in car and bus travel, by the 1930s use of the line was falling and closure became inevitable. On 29 September 1935, the last train ran to much sadness and regret. In the November the equipment was sold off in auction and by the following year all the track had been lifted. It seemed that the line was gone forever.

Over the years there have been several plans to reopen the line in some form, but the sheer amount of work involved and the massive cost it would incur has meant these plans have come to naught. Finally, in 1979 the Lynton & Barnstaple Railway Association was formed. A great deal of work followed involving fundraising, planning applications, land purchase and research until in 1996, over sixty years after it closed, planning permission to reopen part of the Lynton & Barnstaple Railway at Woody Bay was granted. The first steam-hauled passenger train left the station on Sunday 12 March 2005, making it the longest abandoned section of railway to be reopened anywhere in the world.

The charity has plans to extend the track to Blackmoor, Wistlandpound and beyond with sections of land and some properties having been purchased for this to take place. Once that is achieved, the next planned step is to extend on to Lynton. This is just the beginning of an exciting venture to rebuild this outstanding and beautiful railway.

Train arriving at Woody Bay Railway Heritage Line.

5. The Tunnels, Ilfracombe

The Tunnels Beaches in Ilfracombe are one of the region's quirkier visitor attractions. Situated at the bottom of Northfield Road and Torrs Park, they were created in 1823 to take advantage of the burgeoning tourist trade. Hundreds of Welsh miners were brought in to carve out the tunnels by hand, allowing easy access to Crewkhorne Cove. When the project was finished there were three tidal bathing pools, two of which were allocated to the ladies and one for the gentlemen. The site was then renamed 'Tunnels Beaches'. Prior to this the cove had been much used by smugglers. Over the years winter storms have done their damage and now only the ladies pool and part of the smaller pool survive.

Taking two years to carve out, the final length was over 160 meters with 960 cubic meters of rock having to be removed. Six tunnels were originally created. The minors were paid 8d per day and many pickaxe marks can still be seen on the walls of the tunnels. The pools, which took eighteen months to build, were built with boulders and lime mortar between the natural curve of the rocks and horse-drawn wooden bathing machines were wheeled right up to the water's edge so the ladies could maintain their modesty when entering and exiting the pool. Segregated bathing was strictly controlled with a guard positioned between the ladies and gentlemen's pools

Below left: Looking down The Tunnels, Ilfracombe.

Below right: The pump that fed seawater into the Bath House.

The Tunnels at Ilfracombe from the sea.

and if a man was caught spying on the ladies he was liable to be arrested. It wasn't until 1905 before mixed bathing was allowed.

In 1836, the Ilfracombe Sea Bathing Company was formed and erected a stylish new bath-house where both hot and cold seawater baths were available. This was the age where bathing was considered an aid to health rather than a pleasure, so a well-appointed bath-house was essential for any popular resort.

The Tunnels Beaches are a wonderful connection to Victorian Ilfracombe and are still as popular and well used as they were, although segregated bathing is thankfully a thing of the past.

6. Chambercombe Manor, Ilfracombe

The picturesque eleventh-century manor house of Chambercombe Manor nestles in a secluded valley near Ilfracombe. It is a place where the visitor can easily imagine themselves walking into a century from long ago, all thoughts of modern life disappearing. A place filled with legends of smugglers, wreckers and ghost stories.

Mentioned in the Domesday Book, it remained in the possession of the Champernon family until the fifteenth century, then passing into various hands before being owned by the Duke of Suffolk, father of Lady Jane Grey. After his execution for treason in 1554, the house passed to the Crown. The following centuries saw its fortunes fall and at

some point, it became a farmhouse. Finally, in 1979 it was given to the Chambercombe Manor Trust. However, with its plaster frieze, barrel ceiling and magnificent carved four-poster bed, it is easily possible to see the former grandeur of the house.

In the eighteenth century the house may have been used by smugglers, the secluded valley location being the ideal place for hiding smuggled goods from the excise men. There is also said to be connections with wreckers of nearby Hele, but we will never know the truth of these stories. Of course, Chambercombe Manor cannot be referred to without mentioning the famous ghost story and the 'haunted room'. Much is made of this at the manor today, with regular guided ghost walks and other such events.

Legend has it that in 1865 the owner of the house was repairing some damage to the roof and noticed something odd. Although he knew there were only four rooms in that part of the house, he could see five windows. He started to hack away at the wall opposite the unaccounted for window and by the time his wife had returned, there was a hole wide enough to climb through. They found themselves in a room containing some furniture and a four-poster bed. On pulling the curtains aside the horrified couple discovered the skeleton of a woman.

The story goes on that the remains were those of Kate Oatway, daughter of William Oatway, who lived in the house in the eighteenth century. Kate had married an Irishman named Wallace and had moved to Dublin. William needed money, and one stormy night as he was looking out to sea he noticed a badly injured young woman

Chambercombe Manor, Ilfracombe.

Above left: Beautiful stained-glass window in the family chapel.

Above right: The grand carved bed at Chambercombe Manor.

lying on the rocks. He carried her back to the house, but she died soon afterwards. He then noticed the young woman had enough money and valuables on her to solve his money problems, so he decided to steal them. It wasn't until this point in the story that William suddenly realised the dead woman was his daughter Kate. He was said to be so grief-stricken that he sealed her body in a room, never to be spoken of again. There are various versions of this story, another saying the body was that of a Spanish woman who survived the shipwreck only to be murdered by wreckers.

Today, if you decide to go on one of the guided tours, you will hear tales of rocking cradles in ice-cold rooms, footsteps belonging to no one and creaking floors late at night. Whatever your beliefs, the house certainly lends itself to such stories and deserves its place in this book.

7. Combe Martin

The village of Combe Martin, on the edge of Exmoor National Park, is surrounded by some of the most beautiful and spectacular coastal scenery in the county. There are many walks from the village, which are well worth the effort as the views the walker will see are truly breathtaking. Those from the Little Hangman and higher

Great Hangman hills are extremely popular and look out onto the moors and impressive coastline. Now a popular resort, the village has changed remarkably little over the years. The sandy beach is accessible at low tide, with some hidden coves proving fascinating to explore.

The village is believed to have the longest main street of any village in the country and winds along for nearly 2 miles. There are many places to explore and visit, but one of the most unusual must be the Pack of Cards Inn, which was built around 1690 by George Ley, a local squire and councillor whose family owned a great deal of land in the area. Legend has it that after a particularly large win at cards he decided to build a house to celebrate his win. Built on a plot of land 52 by 53 feet, it represents a pack of cards plus the joker. It has four floors to represent the four suits of cards, with thirteen doors and fireplaces on each floor, which equal the number of cards in each suit. There are also fifty-two stairs.

The house changed hands over the following centuries, but it is not certain when it became an inn, although in 1822 records show it was known as the King's Arms Inn with a Jane Huxtable as landlady. The building's name was officially changed to the Pack of Cards in 1933, although it had been called this locally for many years.

The area has had great wealth in its history due to the mining of lead and silver from the thirteenth to nineteenth centuries. The Combe Martin silver mines were of extreme high quality and almost all silver made by the highly renowned silversmiths of Barnstaple is made using Combe Martin silver. Iron ore has also been mined from the beach together with manganese, an important industrial mineral. Evidence of the silver and lead mining can still be found in the area.

Each year over the four days of the spring bank holiday in May the tradition of Hunting the Earl of Rone takes place in Combe Martin. Unique to the village,

The sheltered harbour at Combe Martin.

The rocky coastline at Combe Martin.

the event involves the grenadiers, a pagan hobby horse, a fool and the villagers hunt through the village for the Earl of Rone. He is 'found' on the Monday night and mounted back to front on a donkey and paraded through the village to the sea. 'Shot' by the grenadiers and falling from the donkey, he is revived by the fool and hobby horse, remounted on the donkey and finally 'shot' on the beach and thrown into the sea. The legend is that the earl was Hugh O'Neill, Earl of Tyrone, who was forced to flee Ireland in 1607 only to be shipwrecked on the nearby Raparee Cove in Ilfracombe. It is said he was eventually captured by a party of grenadiers. The ceremony was so raucous and known for the drunken behaviour that it was banned in 1837, but revived in 1974, although it must be noted that the conduct of the local populace is more lawful these days!

8. Woolacombe

The beautiful 3-mile-long golden sands beach at Woolacombe on the North Devon coast must count as one of the most superb beaches in the county, if not the entire country. The gently sloping beach is part of the North Devon Coast Area of Outstanding Natural Beauty. The Atlantic waves hitting the beach are renowned for their large clean swell, making the site a premier area ideal for surfing. It is also worth noting that in good weather there are excellent views of Lundy, which lies 12 miles off the coast.

Woolacombe Beach, together with much of the surrounding area, was privately owned by the Chichester family who acquired the land in 1133 during the reign of Henry I. When Lady Rosalie Chichester, the last surviving member of the family, died in 1949 it had been in her family's possession for over 800 years. Woolacombe, Mortehoe and the family estates at Arlington Court were all willed to the National Trust on her death.

The US Army Assault Training Centre was based at Woolacombe during the Second World War and due to the long flat shape of the beach and the bordering sloping sand dunes, conditions were considered to closely resemble those of Omaha Beach landing area. This meant the beach was used extensively for troops to practice amphibious landing assaults in preparation for the invasion of Normandy

Left: The wide expanse of Woolacombe Beach.

Below: Rippling waves at Woolacombe.

The hills around the coastal village of Woolacombe.

on 6 June 1944. There is a stone memorial to the soldiers positioned on the grassy headland at the north end of the beach, which was dedicated in 1992.

The sand dunes flanking the beach are mainly colonised by marram grass, a fast growing and hardy perennial sand grass, and sea spurge, a species of euphorbia. The coastline itself is part of the North Devon Marine Conservation Area. Woolacombe Beach has continuously been recognised as one of the best beaches in Europe and has won numerous UK and international awards for its services and cleanliness.

9. Croyde

Croyde is set in another magnificent stretch of the North Devon coastline and is one of the main sandy beaches in the area. There are splendid sea views from the road into Croyde, which runs high above the cliffs before dipping down to the village. A long-established self-catering park and popularity with local families meant that the beach was mainly used in the traditional way, with adults and children swimming, or more likely paddling, building sandcastles, sunbathing and eating ice creams. Many years ago, it was famous for a shop selling ice creams with clotted cream on top – quite common now, but a real treat then. In recent years, with the growth of surfing, Croyde has become one of the well-known surfing beaches of the South West.

Looking towards the pretty village of Croyde.

Croyde is part of the parish of Georgeham and is one of the manors mentioned in Domesday Book. The origin of the name is uncertain and may relate to the name of the stream or a geographical feature. Croyde is a straggling village from Down End at one side, with its car park on a slope providing splendid views over the sea, to the headland of Baggy Point at the other. Baggy Point is owned by the National Trust and they have a small car park there with a kiosk where walk leaflets are available. There are several walks starting here, from a gentle stroll to serious rambles along the coast. It is another place where birdwatchers will find plenty of interest, including peregrine falcons, linnets and Dartford warblers. Occasionally, seals and porpoises can also be seen.

Between Down End and Baggy Point is the village, which also has a car park. There are some attractive cottages, some thatched, with a stream running along in front of them. Many of the buildings, including Myrtle Farmhouse, were built in the seventeenth century.

10. St Brannock's Church, Braunton

North Devon abounds with attractive and interesting churches, but one of the most beautiful must surely be St Brannock's in the village of Braunton, to the north-west of Barnstaple. The present church dates from the thirteenth century and sits in the same position as an earlier Saxon church, although it is possible that Christian worship on the site goes back earlier still. Today the church appears to lie on the outside of the village, but originally it would have been positioned in the middle, with the parish's agricultural and fishing communities stretching out either side. However, over the centuries the fishing industry has slowly died off, while the village has extended further southwards towards the estuary and Barnstaple.

St Brannock was a sixth-century Welsh saint, usually associated with Pembrokeshire where there are several churches dedicated to him. It is said that he travelled to Rome and Brittany before making his way through Wales and eventually Devon. Traditionally the story is that the saint had a dream telling him that he should build a church on the spot where he will meet a white sow and her piglets. On entering the church, the visitor should look for the pew end that has a carving of St Brannock with a sow at his feet. His image can also be seen in a stained-glass window and the sow and piglets on one of the bosses in the roof above the font.

The church is built in the Early English and Perpendicular style, consisting of a chancel and nave. The nave itself is unusually wide at 34 feet. A new organ was erected in 1896 by public subscription and in 1887 the bells were rehung with the addition of two new ones at an expense of £1,200.

In July 2003, St Brannock's Church suffered an appalling arson attack, which caused almost £1 million worth of damage. The Jacobean Snow gallery above the north transept was totally destroyed, with the organ suffering fire and water damage, together with the pews and an antique Bible. During the restoration work on the church spire it was discovered that the bulk of the timber had been cut down in the thirteenth century and that the original trees had been planted before 1066. This astonishing fact makes the spire the oldest in the West Country and probably one of the oldest in the country.

The thirteenth-century church of St Brannock's, Braunton.

Pew end showing St Brannock and the sow.

11. The Great Field, Braunton

Saxon Braunton, 5 miles west of Barnstaple, was a wealthy and important royal manor and remained so until the thirteenth century. Today it is said to be one of the largest villages in the country, and is home to Braunton Great Field. Occupying around 350 acres to the south of the village, it is one of only three surviving medieval open-strip field systems in the country. The Great Field is believed to have been established on reclaimed saltings and marsh land and documents show that by 1202 it had already been divided into strips and furlongs. The Great Hedge surrounding the field and forming the boundary is probably of the same date.

Under the Norman feudal system, the populace was divided up into different social orders. Basically, it meant that the lower orders, or peasants, would receive a small plot of land for the use of themselves and their families in return for working the land belonging to the lord of the manor. Large blocks of land were divided up into narrow strips, each covering 1 acre. These strips of land were separated by a mound of earth known locally as landsherds. Then at the end of each one smooth boulders were placed to mark the ownership, known as bond stones. Braunton Great Field is divided into 21 furlongs, each of which contains ten to fifty-six strips.

The Great Field was originally much bigger than it is today. Over the centuries there has been a gradual decline as the land was used for other purposes once the feudal system ended. In 1841, maps show there were 448 strips, but by 1994 there

The village of Braunton, site of the Great Field.

were only eighty-six remaining. Only a small number of farmers work the land today, but it is still possible to spot clues to its ancient past. Many landsherds and boundary tracks still remain in place and the older farmers will tell you that, if you know what to look for in the soil, it is still possible to see where the individual strips of land began and ended. Walking the Great Field really is like a journey into North Devon's medieval past.

12. Braunton Burrows

Braunton Burrows, situated just behind Saunton Sands beach, forms one of the largest areas of sand dunes in the country. Owned by the Christie Devon Estate Trust with part of it leased to the Ministry of Defence, the area was designated a Biosphere Reserve by UNESCO in 2002 due to its environmental and scientific importance, giving the site world status. On first seeing Braunton Burrows, visitors are often struck by how vast the area is. Not surprisingly the site is home to many rare plants and wildlife and has been a site of scientific interest since the seventeenth century. Nearly 500 species of wildflower have been recorded, including the rare sea stock, sand toadflax and water germander, which is only found on one other site in England. Thirty-three species of butterfly and moths have been found, and foxes, moles, weasels, wild mink, hedgehogs, shrews, voles and field mice all call the Burrows home. Rabbits are also in abundance, which is how Braunton Burrows got its name. Adders and grass snakes, newts, frogs and toads, common and sand lizards and a vast selection of insects too numerous to list here thrive in the dunes. The snails and insects in turn attract many birds and as well as all the more common species, chiffchaff, willow warbler, whitethroats and the cuckoo are also regular visitors, with many more often spotted.

There is some evidence of a settlement once existing at the southern end of the Burrows called St Hannah's. There was a chapel too, the ruins of which could be seen as late as 1860. The area included some cottages and some twelfth-century pottery has been found.

Braunton, and in particular the Burrows, were of extreme importance during the Second World War. In 1943, American troops used the site to train in preparation for their assault on the heavily defended Normandy beaches as part of the D-Day landings, with the first troops arriving on 1 September. Due to the large number of troops staying there, some new roads were quickly built. One in particular was the old ferry, which runs across the back of the dunes to Crow Point. This track was widened and straightened and is still known today as the 'American Road'. In 1992 a memorial dedicated to the memory of the soldiers was unveiled by Brigadier General Paul W. Thompson, the same man who had been in charge of the American troops back in 1943.

Braunton Burrows really is an amazing place and with its history and wildlife it should be on any visitors list of must-see places when visiting North Devon.

Left: Saunton Sands Hotel has the best view of Braunton Burrows.

Below: The wide expanse of Braunton Burrows.

Barnstaple and Around

13. Penrose Almshouses, Litchdon Street, Barnstaple

Penrose Almshouses are one of Barnstaple's architectural gems, but are unknown even to many of the town's inhabitants. The narrow Litchdon Street is now a minor road, but was once the main route to Exeter and London.

The almshouses were built with funds bequeathed by John Penrose, a merchant born in 1575 at Fremington, who made his money by trading in woollen goods. He was mayor of Barnstaple in 1620, but died in 1624, and the almshouses were completed in 1627. Built around a spacious courtyard with a central pump, there were twenty dwellings housing forty residents. Each house has a tall brick chimney and small leaded windows, and although many have been restored and replaced over the centuries, their appearance has been retained. The frontage consists of a colonnade with granite pillars, with a lead gutter above decorated with roses and oak leaves. The design of the almshouses is symmetrical, with a chapel having a bellcote at one end and a meeting room at the other end. A central passageway leads

Penrose Almshouses, built in 1627.

The courtyard of Penrose Almshouses.

from the colonnade to the courtyard and dwellings. At the opposite side is another passage leading to a large garden divided into twenty plots, provided so that the inhabitants could be partly self-sufficient. For the early residents attendance at chapel was compulsory. They were also required to be of good behaviour and non-drinkers.

Fifteen years after completion of the almshouses the Civil War began, during which Barnstaple changed hands four times. There are holes in the meeting room door, which are believed to be bullet holes from a skirmish in the town. The interiors of the dwellings have been modernised and the almshouses continue to be lived in nearly 400 years after they were erected.

14. Pannier Market, Barnstaple

Built as part of the major town improvement scheme in 1855, Barnstaple Pannier Market was another example of the work of borough architect R. D. Gould. There was considered to be a great need for a permanent purpose-built site for a market as previously they had been held along part of the High Street, with the panniers filled with produce for sale being located alternately on a weekly basis on either side of the street. During the height of the summer season when fruit was plentiful, stalls were also lined up along Cross Street. As the population of the town grew, this situation was becoming a serious problem and was described as 'An unseemly relic of a barbarous age'. Discussed by the council as early as 1811, it took an

Act of Parliament in 1852 that called for 'The improvement and regulation of the Markets and Fairs' to finally get things moving. The scheme involved a major work of demolition removing a large number of houses owned by the Corporation, and a slaughterhouse. However, even as work started there was opposition to the site being so large. Critics wanted the site to go from the High Street behind the Guildhall and end at Anchor Lane (now Market Street). The agreed plans were considered too large, with fears of it turning into an unused white elephant. The majority decision was carried, however, and the completed design of the market went from the High Street right through to Boutport Street. W. F. Gardiner said of the building: 'The result of this construction is that Barnstaple can today boast of the possession of a Market such as many a county town might well envy. Indeed, Barum's Pannier Market is one of the finest in the Kingdom.'

Officially opened on 2 November 1855, the *North Devon Journal* described it as a 'Red-letter day in the commercial and domestic history of Barnstaple'. They reported on it in detail, and stated that:

> The Butcher's Market comprises thirty-three shops, with a frontage of ten feet 10 inches each. These form an arcade; the pilasters being formed of Bath stone. The height of each shop is 14 feet, with the advantage of facing the north. The roof overhangs the footway of the shops about 7 feet, and is supported by brackets, which spring from the caps of the pilasters. The Pannier Marker itself is about 320 feet in length and about 68 feet in width. The roof is entirely wrought, the timbers being visible throughout. The whole of the centre part of the roof is covered with rolled and fluted plate glass, manufactured by Messrs. Chance, of Birmingham. The timbers of the roof will be stained and varnished; and as a relief, the iron work will have a blue colour.

Above: The ornate wrought-iron roof of Barnstaple Pannier Market.

Right: Barnstaple Pannier Market, built in 1855.

The vast expanse of the Pannier Market.

The Pannier Market, however, was a success from the start and today is as busy and thriving as ever. Local farmers' produce and homemade jams, pickles and pies are still found in abundance on the traditional market days of Tuesday, Friday and Saturday. Every Wednesday the antique market is held, and on Thursdays the craft market takes place.

15. St Anne's Chapel, Barnstaple

St Anne's Chapel, near the parish church in the centre of Barnstaple, is a remarkable survival of a freestanding chantry chapel. Restored with a Heritage Lottery grant a few years ago, it is now an arts and community centre where a wide variety of events are held. It is usually open to the public to visit for a few hours once a week, but it is best to check before planning a visit.

The date of building is unknown, but is believed to be early fourteenth century. There is an undercroft, or crypt, with a massive timber supporting the roof of the upper room. It is believed the crypt was a charnel house, storing the overflow of bones from the burial ground that once surrounded the chapel – the reason for the ground being much higher than the roadway. There is a magnificent beamed roof in the upper floor, which it appears was never ceiled over. The tower was added around 1550 and the building was restored in Victorian times.

Chantry chapels were dissolved, like the monasteries, at the time of Henry VIII's Reformation. The local Corporation purchased the building and it became

Barnstaple's grammar school until a new one was built in 1910. The best-known pupil to be educated here was John Gay, who went on to write the very successful *Beggar's Opera*, which is still performed and was the forerunner of modern musicals.

In December 1685, Huguenot refugees fleeing Catholic persecution in France arrived in the town, and for almost 100 years they were permitted to use St Anne's Chapel on Sundays to hold their church services.

When the grammar school ceased to use the building, it was for several years a museum until the present museum opened in the old Athenaeum building on the square.

Right: The atmospheric St Anne's Chapel in the foreground.

Below: Victorian print showing St Anne's Chapel and parish church.

Parish Church, Barnstaple.

16. Ceiling at the Bank, No. 62 Boutport Street, Barnstaple

No. 62 Boutport Street, now the Bank restaurant next to the Royal and Fortescue Hotel, contains three amazing seventeenth-century plaster ceilings, one of which is considered by Historic England to be 'probably the best piece of urban plasterwork of its period in Devon and has few rivals even in the country houses'.

The date of the actual building is unknown, but the date of 1620 is included in the ceiling and this may well be when the house was built. It was probably built for a merchant, presumably one of those trading with Spain, because the ceiling also includes the arms of the Company of Merchants trading with Spain. Later, in the eighteenth century, the building became a coaching inn – the Golden Lion. The frontage of the building dates from the early nineteenth century. The Golden Lion closed in the early twentieth century and in the 1930s the building was converted into the National Westminster Bank. Later it was occupied by the Woolwich Building Society before becoming the Bank restaurant. Interestingly, when the building

The Bank with its fine seventeenth-century plaster ceiling.

became a bank, it was reported that there was no colour on the ceiling except for the lions' tongues being red. Today the ceiling is well maintained and colourful. Originally the ceilings were in first-floor rooms, but these were removed when it became a bank and the ceilings are now visible as one from the ground floor. The plasterwork includes exotic animals, birds and biblical scenes. The animals include elephants, although they look rather odd, as it is unlikely the plasterer had ever seen a real elephant. At one end is Barnstaple borough coat of arms. Another decorative, if less exotic, ceiling can be seen in the rear room.

These decorative plaster ceilings were fashionable in the late sixteenth and seventeenth centuries and there were many in Barnstaple, but fashions change, and most have now vanished. It is worth the price of a cup of coffee to see these rare survivals.

17. Queen Anne's Walk, Barnstaple

A merchant's walk, or exchange, has existed here since the seventeenth century, with early maps showing the site standing alone jutting into the river. The current Queen Anne's Walk was completed in 1713 as a meeting place for the town's merchants to trade. Facing the Great Quay, where most of the trading ships coming into port would unload, this area would have been full of activity. It may possibly have been designed by the architect William Talman, who is known to have designed similar structures in other parts of the country, although this is not confirmed. The colonnade was financed by the thirteen members of Barnstaple Corporation whose family crests

Queen Anne's Walk, erected around 1708.

are carved above the parapet. The work to erect the building was overseen by Robert Incledon (1676–1758). Incledon was a lawyer, Clerk of the Peace for Devon, Deputy Recorder of Barnstaple and twice mayor in 1712 and 1721.

The elegant colonnade consists of Tuscan columns creating ten bays, four to the right and five to the left of the central bay, above which sits the statue of Queen Anne, given by Robert Rolle in 1708. Directly underneath the statue is a crest celebrating the British victory at the Battle of Blenheim four years earlier. The crest design is based on Roman victory coins and depicts two seated and shackled French prisoners of war surrounded by captured French weapons. On looking closely, the viewer will see two cannons, a halberd and club, a helmet and some muskets. To complete the scene there are two lowered French standards on either side. There is a similar crest at Blenheim Palace. At the base of the statue is the royal crest of Queen Anne herself.

In the centre of the colonnade sits the Tome Stone. Placed here in 1633 and replacing an earlier stone, merchants would seal their deals here by placing the agreed money on top of the stone and shaking hands over it before witnesses. This was then considered a legally binding agreement before law. The stone has the names of three leading merchants of the time carved around the edge. One name in particular, that of John Delbridge, was one of the most well-known men of his age.

The building behind, and entered via the colonnade, was built in 1858 as a public bathhouse by the Wash House and Bath Company. The premises included a small swimming pool, six 'Private baths for ladies and gentlemen, and a 'wash-house for the poor', the idea being that householders could make use of the facilities provided. However, this business was not a success and the company collapsed after ten years. The premises were then acquired by the Freemasons and was converted into a Masonic Lodge. After the Lodge moved to Trafalgar Lawn in the 1970s the building was used as a day care centre for the elderly, then in 1998 it became Barnstaple Heritage Centre. After this closed in 2014 the building was renovated and is now Queen Anne's café on The Strand.

Above left: The Tome Stone where the merchants would buy and sell.

Above right: The crest under the statue of Queen Anne celebrating victory.

18. Pilton Church, Barnstaple

Pilton Church is surprisingly large for what is now a suburb of Barnstaple. For many centuries Pilton was a separate market town with a Benedictine priory founded in the twelfth century. The north aisle of the church was the priory church and priory buildings adjoined the east and north side of the tower. The church has an imposing position at the top of the main street and is entered through what appear to be attractive Tudor almshouses – which actually date from 1849. The building is partly thirteenth century and partly fifteenth century, with some later alterations and additions.

Monuments to members of the Chichester family are a reminder that their manor of Raleigh was within Pilton parish. It is possible the screen into the Raleigh chapel with its initial 'R' was brought from Raleigh Manor when it was demolished in the eighteenth century. There are monuments to Sir John Chichester, who died in 1569, and Sir Robert Chichester, who died in 1627. The latter has life-sized figures of Sir Robert, his two wives, a daughter and two smaller children. The other particularly notable wall monument is to Christopher Lethbridge, who died in 1713, and his family.

Christopher Lethbridge is one of the churchwardens listed on the tablet over the south porch recording the partial destruction of the tower in the Civil War: 'The Tower of this Parish being by force of arms pul'd down in ye late unhappy Civil Wars Anno Dom.1646 was rebuilt 1696.' It is probable that the tower was deliberately destroyed to prevent the enemy from using it as a gun platform.

One of the fine memorials in Pilton Church.

The old rood screen was very fine, but has been badly treated. Originally painted in bright colours, it was later covered in white paint and even later an oak stain was added. The upper part was left in a very bad condition following the removal of the rood loft in the sixteenth century and later still it was built up with a mixture of old pieces. Restoration has begun.

Pilton Church, showing its stone pulpit.

The fine roof of Pilton Church.

19. Green Man Festival, Pilton, Barnstaple

Pilton, once a separate village, is reputed to be the oldest part of the North Devon town of Barnstaple. One of King Alfred's burghs and established by the ninth century, the name is thought to come from 'Pill' meaning creek, and 'Tun' meaning an enclosed farmstead. A charter was granted allowing Pilton to hold an annual market by Edward III (1327–77).

The association with the green man – the ancient symbol of nature and fertility and depicted as a face sprouting foliage – is an old one; although it had fallen into decline over the centuries, the festival has been revived in recent decades. A wonderful green man carving can be seen on the screen between the chancel and the Raleigh Chapel in the church of St Mary the Virgin in Pilton. The current festival takes place on the third Saturday in July each year, with the Green Man Parade beginning on the square in Barnstaple and proceeds along the High Street, Pilton Causeway, Pilton Street and on to the Rotary Gardens. The parade is a marvellous thing to see, filled with brightly coloured costumes, swirling hobby horse characters, drum bands and medieval characters, all led by the massive figure of the green man himself – a tall man walking with amazing ease on stilts, wearing the most wonderful and intricately made face mask. A caped figure proclaiming the start of the festival leads the way.

The entire length of Pilton Street is closed to traffic as craft and plant stalls, food and drink sellers and fairground attractions fill the space along it. The stalls and attractions continue into the Rotary Gardens, where the Green Man Pageant takes place in the grounds of Pilton House. The pageant enacted on the day is well worth stopping to see and is believed to represent the initial antagonism of the two main characters: Prior and Green Man. In the pageant the green man is subsequently incorporated into the Christian church.

Below left: Hobby horse figures parade at the Green Man Festival.

Below right: The green man himself leads the parade.

Characters dance at the Green Man Pageant.

20. Marwood Hill Gardens

Tucked away deep in the narrow winding lanes of North Devon is an unexpected and wonderful garden with a stream, lakes and, in spring, glorious camellias and magnolias.

Open daily from March to September, the garden was created in the 1950s by the late Dr Jimmy Smart. Covering around 20 acres, new areas are still being developed while the older planting is now mature. Providing areas for wildlife is also important, with places where rough grass, piles of leaves and branches are left to provide habitat for various creatures, including moths and butterflies. There is a bog garden with primulas and iris and the National Collection of Astilbes. The gardens are set in a valley with steep climbs up the hills around it. There are plant sales in the walled garden and refreshments available in the tea room. Various events take place throughout the year including an Easter Garden Trail and outdoor theatre performances.

Overlooking the gardens is Marwood parish church on a splendid site looking over the countryside. It is worth a visit and is mainly fourteenth century, although the north transept was enlarged into an aisle in the fifteenth century. It was restored in 1903. There is part of a fine rood screen from around 1520, carved bench ends and a seventeenth-century pulpit. Marwood is a large parish containing many hamlets or smaller settlements, many going back to early medieval times or even earlier. They have fascinating names such as Prixford, Guineaford, Honeywell, Patsford and Kings Heanton. Westcott Barton was yet another home of the Chichesters.

It is easy to get lost among these winding lanes, but the scenery is beautiful and there are brown tourist signs showing the way to the gardens. Although only around 4 miles from Barnstaple, they feel like another world, one where peace and tranquillity reign and relaxation is easy.

Right: Rich autumn evergreen bushes at Marwood Garden.

Below: Boarders and stone tubs at Marwood Garden.

21. Arlington Court

Arlington Court, set among the green fields, woods and hills of the North Devon countryside around 12 miles from Barnstaple, is the only National Trust house in North Devon. The estate had belonged to one branch of the widespread Chichester family for centuries, but the last to live at Arlington was Rosalie Chichester. She died in 1949, bequeathing the house and estate of around 3,500 acres to the National Trust.

It is not a place for a quick visit, and it is advisable to go on a fine day to make the most of the house and grounds. As well as the house, there is a small (by country house standards) formal garden, a walled garden and acres of grass and woodland to explore. A short stroll leads to a peaceful lake, where an urn contains Miss Chichester's ashes. Longer walks can be taken from here, or there is a circular walk leading back to the house. There are several walks of varying difficulty around the estate and the adjoining countryside, which provide ample opportunity for admiring the views.

The house is well worth a visit, although as the façade is grey stone it has a rather austere and gloomy appearance, especially on a dull day. Inside, however, is a cheerful, friendly house that displays the many collections made by Miss Chichester,

Arlington Court, home of the Chichester family.

including shells, model ships and pewter. Many items were collected on her travels, including two world cruises. The restored Victorian conservatory in the garden also houses exotic plants collected on her journeys. Rosalie Chichester was also a keen photographer, developing and printing the photographs herself.

The present house was built in the 1820s, but there were two earlier houses in different positions. The architect was Thomas Lee, who also designed Barnstaple's Guildhall. The kitchen and servants' areas were originally in the basement, but were moved into new extensions in the 1850s and 1860s. These now contain a tearoom for refreshing modern visitors.

Alterations to the main house were also made in 1865 by Rosalie's father, Sir Bruce Chichester, and include the splendid staircase dominating the entrance hall. The main rooms downstairs are shown as one room, but can be divided by sliding screens. They include an ante room, morning room and drawing room. Upstairs various rooms are on display, including Miss Chichester's bedroom, furnished much as it was when she lived there.

A short walk from the house are the stables, which contain the National Trust's carriage collection of around forty carriages. This is fascinating for anyone interested in travel before the days of railways and motor cars. All types of carriage are included, from grand state chariots to humble governess carts, and much information is provided about their history. Also housed there, on loan from Parliament, is the Speaker's state coach.

Arlington is now a peaceful oasis of calm away from the noise and bustle of modern life in towns and cities, but there is plenty to see and do.

View from Arlington Court, overlooking the hills of North Devon.

Fountain in the formal gardens at Arlington Court.

22. Tawstock Church

There can be few more picturesque views than Tawstock Court, near the top of a wooded hill with Tawstock Church emerging from the trees below.

Tawstock Church has been called the cathedral of North Devon. It is not especially large, but is very well maintained and full of monuments. It is also well hidden, so is unknown even to many living in the region. Tawstock is a small, scattered village a few miles from Barnstaple on the opposite bank of the Taw to Bishops Tawton. It is reached by narrow, winding lanes and although it is close to North Devon's chief town, it has a very rural feel.

The reason for the monuments is that Tawstock Court was for centuries the home of the earls of Bath and their successors, the Wrey family. Although the Tawstock estate was mentioned in Domesday Book, the Bourchiers arrived there in the late fifteenth century and it was John Bourchier who became the 1st Earl of Bath in 1536. In 1654 the title became extinct upon the death of the 5th Earl without male heirs. He had supported the Royalist cause during the Civil War and had been arrested by Parliamentary forces one night at Tawstock Court and taken to the Tower, where he remained for several weeks. Both Parliamentary and Royalist troops occupied the court during the wars. The Prince of Wales, later Charles II, dined there when he was lodging

at Barnstaple in the summer of 1645. The Parliamentary general Sir Thomas Fairfax stayed there when he was negotiating the surrender of Barnstaple in the spring of 1646.

The present Tawstock Court is a late eighteenth-century building now in private ownership, but it replaces an Elizabethan mansion that was destroyed by fire. The original gatehouse can still be seen on one of the entrances to the estate. The court had its own entrance to the churchyard from the estate grounds.

The 5th Earl has a massive table tomb in the church and his countess, who died in 1680, is commemorated rather more elegantly with a sculptured standing figure. Numerous other monuments and memorials fill the church, including a grand tomb with life-sized effigies of William Bourchier, 5th Baron Fitzwarren and 3rd Earl of Bath and his wife Elizabeth, daughter of the Earl of Bedford. Their sons and daughters are depicted kneeling at the ends of the tomb. A considerable amount of time would be necessary to study all the memorials, the majority relating to members of the Bourchier and Wrey families.

The church building is early fourteenth century with several later additions, including the south chancel, which was added around 1540. The north transept has a ceiling decorated with eighteenth-century Italian plasterwork. There are carved bench ends, the highly ornate Wrey manorial pew, a sixteenth-century gallery leading to the belfry and numerous other features of note. It is a quite remarkable building and well worth a visit.

Tawstock Church, known as the 'Cathedral of North Devon'.

Left: Some of the spectacular monuments at Tawstock Church.

Below: Beautiful, ornate and secluded Tawstock Church.

23. Bishops Tawton and Codden Hill

Codden Hill is visible from all around Barnstaple and, at 630 feet, is the highest hill in the area. It overlooks the village of Bishops Tawton, around 3 miles to the south of Barnstaple, beyond Newport where South Street becomes Bishops Tawton Road. It is from this road that a good view of Tawstock Court and Tawstock Church can be seen across the river. The village is so called because it was once part of the lands owned by the bishops of Exeter and Court farmhouse, near the church, was once a medieval residence of the bishops, although its present appearance dates from around 1800. The name of the attractive thatched pub, the Chichester Arms, attests to the influence of the Chichester family in this area. One of their several North Devon residences was at Hall, a few miles from Bishops Tawton and the church contains some memorials to members of the family.

There are many narrow, winding lanes in the country around the village, which provide pleasant walking routes away from the traffic on the road. There are also footpaths around Codden Hill, and it is worth walking to the top of the hill to see the view over a wide swathe of the surrounding countryside. On a clear day both Exmoor and Dartmoor are visible. Geologically, Codden is one of a series of 'whalebacked' ridges stretching west to east across the landscape as far as Swimbridge. They are

Codden Hill, visible from all over Barnstaple.

formed of Lower Carboniferous rocks and are the result of tectonic activity. At the eastern end of the summit of the hill is a 'bowl barrow' believed to be from the Bronze Age. Codden Hill is privately owned, but there is permissive access for horse riders, cyclists and walkers.

Older residents remember going up the hill in March when lighting fires to burn off the undergrowth, or swaling as it is known, was encouraged.

Left: Bishops Tawton Church.

Below: Bishops Tawton, 3 miles to the south of Barnstaple.

24. Hall, Bishops Tawton

Hall, around 2 miles from Bishops Tawton, is one of North Devon's hidden gems. It is approached by a long winding track through woodland. The house is superbly situated on a slope overlooking the Taw Valley, providing wonderful views for miles around. The inland countryside of North Devon may not be as dramatic as its coastline, but the views are delightful, and it has a peaceful beauty of its own, especially on a calm, sunny day.

The estate is named for an early owner, Simon Hall, whose daughter Thomasine married Richard Chichester in 1461. It has belonged to the Chichesters ever since and is now the only one of their North Devon properties still in the family.

The present Grade II listed house is a neo-Jacobean construction of 1844–47, designed by Philip Hardwick and R. D. Gould for Robert Chichester. He appears to have been a well-liked, rather eccentric gentleman and, as his obituary in the local paper expressed it:, 'the noble mansion itself … perpetuates the evidence of his fondness for medieval architecture.' In his earlier days he was fond of the 'vigorous exercise of bell-ringing' and was very knowledgeable about the subject. His mansion

The Grade II listed Hall, Bishops Tawton.

Above: The medieval-style banqueting hall.

Below: Stunning views from the grounds of Hall, Bishops Tawton.

contains a central staircase hall, but the most remarkable room is at the far end of the building where can be found a large, medieval-style banqueting hall. It includes a minstrels' gallery, heraldic stained glass, arch-braced roof and massive fireplace with motto. Although the previous manor house has vanished, there are outbuildings at hall that belong to the earlier property. These include a large, stone barn, a granary and a long range of partly seventeenth-century stables with a clock tower. These buildings are gradually being restored.

Although not open to the public on a regular basis, visits can be arranged by groups or individuals at certain times. Hall is also a wedding and events venue and provides bed and breakfast accommodation.

25. Tarka Line

The 39-mile-long Tarka Line connecting Barnstaple and Exeter is easily one of the most picturesque and scenic railway lines in the country. Named after the book *Tarka the Otter* by Henry Williamson published in 1927, the line follows the gentle valleys of the rivers Yeo, Taw and Creedy for much of the route, passing through Chapelton, Umberleigh, Portsmouth Arms, Kings Nympton and Eggesford, then going on to Lapford, Morchard Road, Copplestone, Yeoford and Crediton until finally arriving at the city of Exeter. On looking out the train windows the traveller passes tiny hamlets, thatched cottages, meandering rivers and utterly beautiful scenery. It is unquestionably one of the prettiest rail routes in the UK.

The village postman at Umberleigh, on the Tarka Line.

The Tarka Line, named after Tarka the Otter.

The line was opened in 1854; however, North Devon did not get the railways without considerable struggle. It was 1836, in the early days of steam travel, that talk first started of getting a railway line running through from the market town of Barnstaple to the county city of Exeter. When Brunel was building his Great Western Railway in Bristol, he had originally intended for it to extend all the way to Barnstaple, but several rival railway companies that had come into creation due to the success of this new form of travel, had argued among themselves to such an extent that nothing came to fruition. £50,000 had to be raised locally to complete the project, most of it coming from Lord Portsmouth, who was an extremely enthusiastic advocate of the railway coming to North Devon. On being asked if part of his estate at Eggesford could be used for the track, he replied, 'Take what you want; go through my drawing-room if you like, only we must have this line.'

There was great rejoicing at its eventual opening on 12 July 1854, with a banquet held in Barnstaple Corn Market for 760 guests, and 600 'poor people' were entertained to tea in North Walk. A grand procession ended the day's events, to which all the North Devon towns contributed.

South Molton and Around

26. South Molton

South Molton is a small market town around 12 miles from Barnstaple. Unlike some of the larger towns, it has retained many independent shops, together with a pannier market on Thursdays and Saturdays.

A good place to begin a visit is in the museum, although it is best to check times as it is closed in winter. The museum is housed in the town's eighteenth-century Guildhall, an attractive building on Broad Street with arches over the pavement. Some of the building materials and interior fittings were purchased when the Grenville House at Stowe, Cornwall, was demolished. Opposite the Guildhall is a path leading to the parish church with its tall tower. The building is mainly fifteenth century with nineteenth-century alterations and additions.

The town was a centre of the woollen industry, which was highly important to North Devon. It also developed a busy coaching trade and grew in population until the mid-nineteenth century. The coming of the railways ended the coaching trade here, as in so many other places, although South Molton did have its own railway station until 1966. Both the grandfather and father of the painter J. M. W. Turner were born in South Molton, although his father moved to London before his son's birth.

South Molton, like much of North Devon, tended to be Nonconformist in religious matters and a supporter of Parliament rather than the king during the Civil War. When the Earl of Bath from Tawstock Court visited the town to read the king's commission of array he was forced to retreat by a violent mob. Another violent incident, which is now largely forgotten, was the night in March 1655 when South Molton saw the last act of a failed attempt to restore the exiled Charles II to his throne by military action. Sir John Penruddock, Sir Joseph Wagstaffe and their followers fought the Parliamentarians for three hours in the streets of the town, in the course of which it was reported that the mayor was shot but expected to do well. Penruddock was captured and later executed at Exeter. Wagstaffe escaped, it was said, by leaping his horse over the north wall of the churchyard. The wall used to be known as 'Wagstaffe's Wall' with a gate called 'Wagstaffe's' nearby. Fortunately, today South Molton is a peaceful country town where visitors are welcome.

Above: The Red Lion Inn, South Molton, 1905.

Below: Broad Street, South Molton, 1911.

27. North Devon Show, Umberleigh

North Devon's premier agricultural show is now held at Umberleigh Barton Farm, in Umberleigh, just over 8 miles outside Barnstaple just off the A377. The site is completely level and covers a huge area of approximately 50 acres. The North Devon Agricultural Society, a registered charity established in 1966, now run the event, which over the years has incorporated the Instow and Torrington shows. Previous to this the show was held at Alverdiscott, 8 miles to the west of Umberleigh.

Agricultural shows first became popular in the nineteenth century as a way for rural communities to socialise and celebrate their achievements and just to enjoy a break from their day-to-day routine. Opportunities to travel were not as wide as they are now, and the annual agricultural show was an important occasion in the year. The combination of serious competition, stands selling and displaying trade goods, availability of information on the latest products and animal husbandry together with light entertainment, was a winning one and an acknowledgement and reward of all the hard work and skills of rural families.

Judging the dressage competition at the North Devon Show.

The show today has visitors from many walks of life of course but is still based on the original principles of celebrating and supporting North Devon's rural roots. On first entering the venue it is quite staggering how massive the site is. The vast show marquees stretch across the site, with each allocated to a different speciality, such as crafts and gifts, horticultural displays, pig and poultry exhibitions and the unmissable food hall filled with a cornucopia of the best and most delicious food and drink from the region. Not forgetting the extremely popular beer tent! The visitor can enjoy the horse and dog shows, watch the judging of the different livestock categories and marvel at the different breeds on display. There are also hundreds of trade and charity stands to see. It really is the most wonderful day out and an unmissable day in North Devon's calendar.

Left: The livestock competitions are a major feature at the show.

Below: Local farmers relax in front of the latest farming equipment.

28. Castle Hill, Filleigh

Castle Hill, Filleigh, is an impressive mansion and estate that has belonged to the Fortescue family for centuries. It forms an attractive picture seen from the Barnstaple to South Molton road with the central block of the house crowned by its cupola and wings on either side. This layout was determined by the hillside terrace site on which it is built. The extensive gardens and grounds are open most days except Saturdays and are well worth a visit. A tearoom is open during the summer season. Although the house is not open to the public the west wing function room is available for weddings and other events.

The estate came to the Fortescues by marriage in 1454, but an earlier house was replaced in the late seventeenth and early eighteenth centuries. Tragically, in 1934 fire broke out in the central block of the house, claiming the lives of two servants. The house was rebuilt, but much of the contents had also been destroyed. The grounds are largely eighteenth century, with later additions. In front of the mansion are formal terraced lawns. A focal point was deliberately provided by a triumphal arch built at the end of a tree-lined avenue. There are woodland gardens by a river and walks, some very steep, take you to the top of a hill where the ruined 'castle' is dramatically sited. It was never a castle, but a folly built in the middle of the eighteenth century, from which Castle Hill takes its name. Its earlier name was

The woodland gardens of Castle Hill, Filleigh.

simply Filleigh Manor. There are splendid views of the surrounding countryside from here. Other smaller follies include temples and a bridge. It is a good example of eighteenth-century landscape gardening. Even the parish church was moved in 1732 to fit in with the plans. In spring the gardens are glorious with camellias, magnolias, rhododendrons and azaleas.

Above: Castle Hill, Filleigh, home of the Fortescue family.

Left: The picturesque eighteenth-century gardens of Castle Hill.

29. Chittlehampton Church

The parish church of St Hieritha at Chittlehampton is one of the most remarkable in North Devon with a spectacular tower. St Hieritha is also known as St Urith. She was a Christian martyr, probably from the sixth century, devoted to the religious life, who was said to have been put to death by haymakers' scythes at the instigation of a jealous and probably heathen stepmother. At the spot where she fell a spring of water appeared and flowers bloomed – St Teara's or Taddy (both corruptions of St Urith's) Well marks the traditional site of her death at the eastern edge of the village. Writing in the late sixteenth century, Westcote described Chittlehampton as a village famous for St Hieritha, 'whose miracles are able to fill a whole legend, who lived there and was there buried'.

The church was rebuilt in the years from around 1470 to 1520 and much restored in 1871–74. The tower was the last part to be rebuilt and is, according to Hoskins in his history of Devon, 'unquestionably the finest church tower in Devon, combining the strength of Devon towers with the grace of Somerset'. It is 115 feet high and has

The parish church of St Hieritha, Chittlehampton.

six buttresses and battlements with openwork quatrefoil decoration. The whole is finished with eight openwork pinnacles. These have caused problems, however, as in 1987 when a pinnacle came down in high winds and fell into the nave. Two pinnacles toppled in 1988 and 1998, but all were restored.

There is much to see inside the church. The pulpit has survived from about 1500 with a figure of St Urith on the side. Before the Reformation the shrine of St Hieritha was a site of pilgrimage. Following later alterations, it is now an extension to the north side of the sanctuary with an ancient stone bearing an inscription to Joan Cobley (*c.* 1550), but it may be much older and have covered the saint's remains. At the suppression of pilgrimages her image was removed from a nearby niche, but there is little doubt that she was buried here.

There are several monuments and memorials, particularly in the north transept or Giffard Chapel. The south transept, or Rolle Chapel, contains a monument to Samuel Rolle of Hudscot and his parents. The ancient parish chest kept there is probably much older than the present church.

The church forms one side of an open square at the centre of the large village of Chittlehampton. The settlement was established early in Saxon times, probably around 700. In the 1870s cottages surrounding the churchyard were removed, resulting in the present open appearance. In 1889 the Bell Inn was built by the Rolle estate, who owned much property in the area. It is now the only public house in the village and offers accommodation as well as food. Chittlehampton is one of the few villages in North Devon where there are still thatched cottages, contributing to the village's picturesque appearance.

The thatched cottages of Chittlehampton.

30. Eggesford Forest

It must be admitted that Eggesford Forest is on the very limits of what might be considered North Devon, but it is accessible from Eggesford railway station, which is roughly halfway between Barnstaple and Exeter on the Tarka Line.

In 1956 the Queen visited the forest to celebrate the achievements of the Forestry Commission and to record the planting of the millionth acre of trees. A commemorative stone at Hilltown Wood marks the visit. Some of the first trees planted in 1919 by the Forestry Commission are still standing in the woods here. Various woodlands make up the forest, with the early trees being in Flashdown Wood, and the remains of a motte-and-bailey castle at the northern end of Heywood Wood. Various trails and paths link the woods and make for interesting walks with the different habitats supporting a variety of wildlife. If you are lucky, otters and kingfishers are sometimes spotted down by the river.

There is no village at Eggesford – the railway station is there because it was a condition of the landowner when he agreed to allow the railway to cross his land.

Below left: Eggesford Forest, run by the Forestry Commission.

Below right: The small church at Eggesford, restored in 1867.

The church of All Saints is now an isolated building, but it was once close to the old Eggesford House, demolished in the early nineteenth century when a new house was built a mile away. The church is small and was much restored in 1867, but it has some very fine monuments. Eggesford was another estate that came to the Chichesters by marriage in 1606 and they are represented in the monument to Edward and Anne Chichester and the alabaster figures of Arthur Chichester, Earl of Donegal and his two wives. There is also a good monument to Edward Fellowes, who bought Eggesford in 1718.

31. Tarka Trail

One of the best ways to explore the beautiful countryside of North Devon is to get yourself a map of the Tarka Trail. Named after Henry Williamson's famous book *Tarka the Otter*, which he set in real places around the county, the 180-mile route follows, as near as possible, the story of Tarka's life and the places he lived in. The figure-of-eight route is centred around Barnstaple, with the north loop travelling

Part of the 180-mile Tarka Trail.

through Woolacombe, Ilfracombe, into Exmoor and Lynton then on to the Valley of the Rocks. The southern loop runs alongside the River Torridge and through Bideford, Torrington, Hatherleigh and Okehampton, reaching the edge of Dartmoor and then heading back towards Barnstaple. As you walk the route you pass through some of Devon's most stunning and beautiful scenery. Follow Tarka's story through valleys and ancient villages, along the banks or rivers and rugged moorland, dramatic cliffs and golden beaches. The Tarka Trail is one of Britain's longest continuous traffic-free walking and cycling paths and is also part of the Devon Coast to Coast Cycle Route. The maps available are usually broken up into short sections on the route, which vary from easy to challenging, shorter or longer, inland or coastal, so there is much to choose from.

There are many ways to enjoy this route depending on the visitor's interests. For those who love the *Tarka the Otter* story I would recommend taking the book *Tarka Country Explored* by Trevor Beer. The author follows Tarka's tracks along the route and those described in the book and has included superb notes on the wildlife and characters in the story.

It is impossible to mention specific places of interest or recommend wonderful places to stop and eat, as this short piece of writing isn't long enough to list them all, I can however assure the reader that they will not regret a single moment spent enjoying this beautiful part of the country.

Looking across the estuary on the Tarka Trail.

A rainbow over the Barnstaple section of the Tarka Trail.

32. Torrington Common

On a dark, wet February day in 1646 the Royalist commander Lord Hopton assembled his horse troops on Torrington Common. The Parliamentarian leader, Sir Thomas Fairfax, and his army were advancing on the town. Lord Hopton 'commanded 200 horse into the town…'

This was probably the most dramatic event to occur on Torrington Common. Fortunately, these days it is a peaceful, green space with wide views over the surrounding countryside and a variety of walks. The dramatic events now happen courtesy of the charitable organisation, the Torrington Cavaliers, who organise spectacular bonfires. In 1996, on the 350th anniversary of the Battle of Torrington, they built a model of the parish church, commemorating the tragic and almost certainly accidental explosion in the church during the battle, which destroyed part of the church and killed over 100 Royalist prisoners held there. They have a mass grave in the parish churchyard. In 2005, to commemorate the battle of Trafalgar, the model was of HMS *Victory* and the next bonfire is planned for August 2020, when as part of celebrations marking 400 years since the sailing of the *Mayflower* from Plymouth, a model of the *Mayflower* will become the centre of the bonfire.

Torrington Common, like the town, is on a ridge commanding glorious views of the wooded hills around and the River Torridge in the valley below. Traditionally, it is believed that William, Baron of Torrington, gave the common pasture of the

Torrington Common in the summer.

The spectacular bonfire to commemorate the Battle of Torrington.

town to the burgesses in the late twelfth century and they have belonged to the townspeople ever since. The hills are quite steep in places, making walking fairly strenuous, but refreshment is available in the Puffing Billy, a licensed café in an old railway station building at the bottom of one of the footpaths on to the common. It is on one of the old railway lines, which are now part of the Tarka Trail walking and cycling route. Torrington Common is also one of the places where, on some summer days, the welcome sight of Hockings ice-cream van can be seen.

33. RHS Rosemoor, Torrington

Managed by the Royal Horticultural Society since 1988, the beautifully maintained and tranquil 65-acre site of Rosemoor Garden is an enchanting place to visit. The RHS describes the garden as: 'Retaining the essence of rural North Devon within a dramatic backdrop of steep wooded valley sides.' A fitting description for the mix of formal and informal gardens, woodland walks, water features and serene open spaces.

In 1923 Rosemoor House, which sat at the far end of the original 8-acre garden near Torrington, was bought by Robert Horace Walpole, the 5th and last Earl of Orford. On his death in 1931, his daughter Lady Anne took over the gardens,

although she did not move in permanently until 1947 with her husband Eric Palmer and their young son, when they regained possession of it from the Red Cross. During the Second World War the house had been used as a temporary refuge from the bombing for people from London's Docklands and the East End. The Palmers ran the estate as a dairy farm for several years, until the herd of fifty Ayrshire cows were sold and the pastureland was rented out to local farmers for grazing. Then, in 1988, Lady Anne donated the house together with the 8 acres of established garden and 32 acres of pastureland to the Royal Horticultural Society. The RHS has since bought large areas of woodland bordering the original garden.

The following year work began on building a visitor centre with panoramic views across the garden, including a shop, restaurant, lecture theatre and plant sales area. Officially opening to visitors on 1 June 1990, the superb gardens are well worth visiting throughout the seasons. Starting with the classic formal garden, go on through the Hot Garden or the Foliage Garden and then perhaps the tranquillity of the Cottage Garden – the choice is endless. It is tempting to walk among the trees and flowers and lose yourself in this peaceful, quiet place forever.

RHS Rosemoor Gardens cover a 65-acre site.

Above: A spectacular display at Rosemoor Gardens.

Left: A tranquil stream in the wooded gardens of Rosemoor.

34. Dartington Crystal, Torrington

Today Dartington Crystal is the major private employer in Torrington and surrounding rural areas and stands as the only working hand-made tableware-producing crystal factory in the UK. As well as the beautiful and unique designs they are famous for, the wonderful thing about Dartington Crystal is visitors can go on the factory tour. It is utterly fascinating to look down from the visitor platform and watch a piece of glass being created right before your eyes. Watching the skilled glass-maker begin the process with a lump of molten glass, then mouth blowing it into shape using a blowing pipe, moulding handles and stands to create a thing of beauty, is mesmerising.

The company was founded by the Dartington Hall Trust, a charity set up in 1920 to assist the economic regeneration of rural areas through business, education and the arts. In the early 1960s there was concern about the lack of job opportunities

Above left: Glass-makers in action, viewed from the visitors' gallery.

Above right: A skilled glass-maker creating a unique piece of glass.

in North Devon, which was causing young people to move elsewhere to find work. Then in 1967 a glassmaking factory was set up to help solve this issue. However, the company would need commercial success to survive, so Swedish glass manufacturer Eskil Vilhamson was hired as the company's managing director and he brought with him a team of Scandinavian glass-blowers, many of whom stayed for many years. The factory opened in June of that year under the name of Dartington Glass. More expert glass-blowers were hired, including one Italian and two from Denmark. The clean, simple and functional design style based around the age-old Scandinavian techniques was an instant success. Demand quickly outstripped production and in the 1970s the factory expanded, followed by another expansion a decade later when Wedgewood took up a large stake in the business. Over the following years the company has changed hands, had management buyouts and bought other companies under its wing.

Today around 1,400 pieces of glass are made each day; that is around 350,000 per year. A visit to the award-winning visitor centre to watch the talent and artistry of these gifted glass-makers is well worth seeing.

Bideford and Around

35. Fremington Quay

Fremington Quay, situated 3 miles from Barnstaple, is a small inlet of the River Taw known as Fremington Pill. It can be reached from either the main road through Fremington (the B3233) or along the Tarka Trail and South West Coast Path.

In 1838, the Taw Vale Railway and Dock Company was formed to build a deepwater quay at Fremington together with a horse-drawn rail link direct to Barnstaple. The quay became a busy industrial port and within a few years became the busiest port (based on tonnage) between Bristol and Lands End. As the population of North Devon grew, industry flourished and by the 1890s twenty-nine men were employed on the railway alone. Limestone and culm, gravel (to be mixed with Fremington clay and used in potting), granite and lead ore were imported, with coal being the major import. During the Second World War, 88,000 tons of coal were unloaded and sent out all over the region. Many of the large blocks of stone used for ballast in the ships went towards the building of Fremington Methodist Church along Old School Lane. Ceramics, local produce and huge quantities of ball clay were exported mainly to Europe for the manufacture of toilets and clay pipes. The very fine white clay was much in demand due to its quality. However, due to changing economic fortunes and manufacturing processes the last clay train ran in 1982.

Now redeveloped as a conservation area, the old railway line has become part of the Tarka Trail cycle track. The railway building is now Fremington Quay Heritage Centre and Café. This busy industrial site has become a place of calm relaxation with fabulous views over the River Taw estuary.

Fremington Quay is also one of the best places in the area for those interested in bird watching. Wading birds such as Curlews can be seen, their long, slender downcurved bills digging in the estuary mud for worms. Oystercatchers and Spoonbills are frequent visitors, together with various types of heron, ducks and gulls. Occasionally rare visitors are spotted, such as the Glossy Ibis, Western Cattle Egret, Snow Goose and even a Bonaparte's Gull has been sighted.

After a spot of birdwatching it is the perfect opportunity to go in the café and enjoy a generous slice of cake and a pot of tea or stop longer for lunch. It is also an excellent spot for picnicking before setting off on a gentle stroll along the old railway track and perhaps watching the sun set over the estuary.

Above: The old railway track at Fremington Quay.

Left: Fremington Woods lead down to the quay.

36. Bideford Bridge

Just as Barnstaple has its ancient bridge spanning the Taw, so Bideford has its bridge spanning the Torridge. Unlike Barnstaple's bridge, the twenty-four arches of Bideford's bridge are of different widths, as the original bridge was built of timber and the arches varied with the size of the timbers. That early bridge was built in the late thirteenth century, replacing the ford, which is referred to in the place name – the first part, 'Bide', is of uncertain origin and may be derived from a personal name, or a geographical feature. That early bridge was rebuilt in stone around 200 years later.

An early form of protection from the action of the river against the base of the bridge was to use mussels placed there as a defence. There used to be a notice forbidding removal of the mussels and there were occasional prosecutions of those who took them. As with all major bridges of that age it has been widened several times since its construction. Pavements were added in 1795–1810 and major work was carried out in 1923–25. It is believed to be the longest bridge in Devon at 678 feet. The 'Long Bridge' of Barnstaple is only 530 feet. Bishop Stapledon left money in his will for the upkeep of both Barnstaple and Bideford bridges and in medieval times there was a chapel at each end of the bridge.

The bridge is an attractive feature of Bideford and can be seen from some distance along the riverbanks. It is best viewed on a fine day when there is plenty of water in the river. The old bridge can nowadays be looked down on by those travelling across the modern downstream Torridge Bridge built in 1987. The new bridge has relieved the pressure on the older bridge, which is no doubt a good thing. One night in January 1968 two arches started collapsing into the water. No one was injured, but it caused a great deal of inconvenience for travellers who had to journey miles out of their way to cross the river.

Bideford Bridge, showing the different-sized arches.

37. The Quay, Bideford

Bideford Quay reflects the town's long association with shipping and the sea. Unlike Barnstaple, its ancient rival on the Taw, Bideford is still a working port and ships can often be seen here. Near one end is the statue of Charles Kingsley, who greatly increased the number of visitors to his 'little white town' with the popularity of his novel *Westward Ho!* Victoria Park adjoins the quay area and is an attractive open space beside the river, one feature of which are the cannon, supposedly from the time of the Armada. Near the park entrance is the Burton Art Gallery with its cafe. Refurbished and extended in 1994 there are permanent and visiting exhibitions.

The ever-changing river dominates the scene, endlessly flowing out to sea and back in again. Calm and peaceful on a fine day, it must be remembered that heavy rain and stormy weather can cause it to flood, which can be a problem for cars parked too close to the edge.

The Grenvilles were lords of the manor and many of Richard Grenville's Elizabethan expeditions to the New World started here, manned by local seaman. Bideford grew prosperous on trade with the new colonies, particularly the Newfoundland fisheries and the new crop of tobacco.

Bideford Quay is still a working port.

BIDEFORD PROMENADE

Promenade at Bideford Quay, April 1905.

The first mention of a quay is in 1619 and a new quay was begun in 1663. Numerous alterations and extensions have been made since then. There are several old buildings lining the quay roadway, although they have been much altered. Many were public houses, although the only one to survive as such is the Kings Arms. The building next door is remembered by many locals as the Rose of Torridge restaurant, named for the heroine of Charles Kingsley's *Westward Ho!* Prior to that the building had been a private house before becoming the Newfoundland public house and then the Old Ship Tavern. History is all around you.

38. Appledore

This village on the estuary of the Taw and Torridge was first mentioned in 1335, but it is almost certainly the place known earlier as Tawmouth. In the Anglo-Saxon Chronicle it is referred to as Tawmutha when Harold's three illegitimate sons crossed from Ireland in 1069 with sixty-four ships, landed here and were beaten off with great losses. It is a picturesque village with narrow streets and colour-washed houses, which relied chiefly on fishing and shipbuilding for its prosperity. Until 1814 it was part of the port of Barnstaple, but then became part of the port of Bideford. The quay was built in 1845, later extended and widened in 1939–41.

Shipbuilding is still represented by the large covered buildings of Appledore Shipyard, although to the dismay of many locals its closure has recently been

Above: Irsha Street slipway, known as 'Moody's Slip'.

Left: Irsha Street, Appledore, was once a tiny hamlet.

Below: Looking across the estuary from Appledore front.

announced. The more modern industry of tourism is also now important for the village. It is the home of North Devon's famous Hocking's ice cream, which has been made in the village since 1936. During summer months their vans are a familiar site in North Devon, being seen on Torrington Common, Bideford Quay, Westward Ho! and Ilfracombe, as well as attending various events. More recently Appledore has become famous for its book festival, an event established in 2006 that takes place in September every year with many well-known authors attending. In 2018, authors included Michael Palin, Kate Mosse, Michael Morpurgo and Anthony Horowitz.

The village is also home to the North Devon Maritime Museum, housed in a Georgian building that has been home to several ship owners over its lifetime. It covers the shipbuilding and seafaring history of North Devon through the ages, as well as providing details of shipbuilding techniques. Wrecks and rescue sections provide information about the Royal National Lifeboat Institution. Appledore is one of several coastal settlements in North Devon that is home to a lifeboat station.

39. Instow

Opposite Appledore on the Taw and Torridge estuary, where the two chief rivers of North Devon flow out into the sea, is Instow. The two villages make an attractive picture, and this is one of the best places in North Devon to see the sun setting over the water at the end of a fine summer's day. There are often yachts and small boats on the water and if the tide is in the scene is splendid and offers ample opportunities for artists. Some caution is required, as if the tide is out it may look possible to walk or drive across to Appledore, but it is not, and the currents can be dangerous. A ferry sometimes operates between the two villages. Instow has a small sandy beach with dunes and several places to eat. It is also on a bus route, so is one of the more accessible seafronts in the area.

Instow was on the Barnstaple to Bideford railway line, which has now become a walking and cycling route, so for the more active it is possible to walk along the rivers in both directions. The signal box at the old Instow railway station has been restored and can sometimes be visited. The remains of an old limekiln can be seen a short distance along the railway path towards Bideford.

Instow became increasingly popular as a watering place during the nineteenth century. As early as June 1843 the local paper reported that 'this pleasant little village is completely filled. The North Devon Cricket Club commenced operations this month and intend holding meetings twice every month during the season'. In 1849 it was said to be popular with 'invalids' in winter for 'the mildness of the air and healthfulness of the climate'. Tourists have visited Instow ever since, with a guidebook of 1966 remarking: 'the splendid stretch of firm sand makes Instow an ideal place for children … sailing is delightful in the wide reaches of the breezy Torridge.'

A quay was built in the 1620s and there were potters at Instow in the eighteenth century and probably earlier, but in the nineteenth century the pottery sites near the water disappeared. They were often replaced by guesthouses, as seaside holidays

became increasingly popular and the railway made travel easier. A sailing club was founded in 1905, later becoming the North Devon Yacht Club. As early as 1841 there was a regatta at Instow, when there was a prize of two sovereigns for the main race of pilot gigs. It was reported that there were many who took advantage of the 'excellent ordinary' (a set meal at a set price) served at the Marine Hotel on the seafront. This hotel was still there in 1966. The Appledore and Instow Regatta is now an annual event.

The 1966 guidebook also mentioned that the view from the churchyard is superb, but most visitors probably never see the church, as it is on a hill around three-quarters of a mile away from the seafront.

Above: Instow seafront.

Left: The long, golden sand beach at Instow.

Tide coming in on Instow Beach.

40. Tapeley Court

Not far beyond Instow on the way to Bideford the early nineteenth-century neo-Grecian lodge can be seen at the entrance to Tapeley Park. Tapeley was a Domesday manor, but the present mansion began with the house built in the early eighteenth century when the estate was purchased by a Scottish naval commander called William Clevland. He is said to have admired the site when sailing into Bideford. He married Ann Davie, the daughter of a Bideford tobacco merchant. The house was extended and altered at various times, but the present appearance of the building is due to a transformation of 1898–1916. It was Lady Rosamund Christie, wife of Augustus Langham Christie and daughter of the Earl of Portsmouth of Eggesford House, who at that time employed the architect John Belcher to remodel the house. The last Clevland had been Archibald, who died aged twenty-one at the Battle of Inkerman during the Crimean War. His eldest sister and co-heiress had married William Langham Christie of Glyndebourne. A later Christie founded Glyndebourne opera house, but he bequeathed Tapeley to his daughter Rosamund, who in turn left it to her nephew and the current owner, Hector Christie.

The house is only open to groups by appointment, but the extensive grounds are open regularly from late March to late October. There are gardens from different periods, including an eighteenth-century walled kitchen garden and Italianate terraced gardens from Tapeley's early twentieth-century transformation. A Georgian brick dairy is now the tearoom. There are woodland walks with ancient trees leading to a lake and a children's play area. The present owner has long been passionate about organic farming and sustainability and the estate includes one of the country's oldest permaculture gardens and a straw bale house. The gardens also provide splendid views over the estuary and out to sea.

Above: The lodge house at Tapeley Park.

Below: Looking across to Tapeley Court grounds.

41. Westward Ho!

Westward Ho! is a flawed gem set in one of the most spectacular coastal sites in North Devon. Unfortunately, as W. G. Hoskins remarked in his history of Devon, 'Westward Ho! is a sad spectacle of what uncontrolled speculative building can do with a fine site.' His book was published in 1954 and building is no longer uncontrolled, but it was a sad ending for what was begun as a fashionable watering place to rival Torquay. Luckily it is impossible to spoil the cliff walks and sea views. Walk beyond the caravans, chalets and beach huts and find the green spaces and coastal walks. Just before the green spaces start is the Pier House restaurant, a reminder of the short-lived pier constructed there in 1871. Damaged by storms it was dismantled in 1880. The Pier House was previously known as the Elizabethan, originally a club for holiday camp residents before being opened to the public. The Braddick family have been associated with the holiday business since 1937 when Hobart Braddick established a nearby holiday camp.

The place name is highly unusual: it has an exclamation mark and is the title of a novel published eight years before the place existed. Prior to 1863 the area was simply regarded as part of Northam Burrows, but in that year the Northam Burrows (North Devon) Hotel and Villa Building Co. Ltd was formed and the Westward Ho! Hotel opened in 1864. The original *Westward Ho!* was a historical novel written

The rugged landscape of Abbotcham Cliffs, Westward Ho!

by Charles Kingsley. It tells the story of Amyas Leigh who joins Francis Drake at sea and becomes embroiled in the conflicts between England and Spain. It was published in 1855 and was an immediate success. Kingsley did not approve of the new development named after his novel and never visited.

The United Services College for the sons of servicemen was established in 1874 in what is now Kipling Terrace. Together with Kipling Tors this is a reminder of Westward Ho!'s other literary connection, as Rudyard Kipling was educated at the college and it is the setting for his novel *Stalky & Co*. Splendid sea views can be seen from the paths on Kipling Tors, which are now owned by the National Trust.

Westward Ho! was successful for several years, with retired army and navy officers forming a large part of the population. A major attraction was the North Devon and West of England Golf Club formed in 1864 with a ladies golf club following in 1871. It became the Royal North Devon Golf Club when it was patronised by the Prince of Wales (later Edward VII). The club still exists and claims to be the oldest in England.

Westward Ho! and Northam Burrows share another unusual feature in the Pebble Ridge, a natural feature nearly 2 miles long. The pebbles are somewhat uncomfortable to walk on, but an interesting feature of this part of the coast. Although Westward Ho! is more interesting than it might at first appear, it is the stunning scenery with the cliffs and glorious sea views that make this area of the coast so rewarding to visit.

Westward Ho! is set in spectacular coastal scenery.

Brightly coloured beach huts at Westward Ho!

42. Weare Giffard

Weare Giffard is a village situated on the banks of the winding River Torridge, a few miles from Bideford. There is an ancient hall, an old church on a hill and Halfpenny Bridge, so named because when it was built around 200 years ago it was a toll bridge and the charge for foot passengers was a halfpenny.

The name Weare probably derives from a fish weir, of which there were several on the Torridge. Giffard is the name of one of the earliest families to hold the manor. Eventually the manor came to the Fortescues when in 1454 Sir Martin Fortescue married Elizabeth Densyll, heiress to Weare Giffard and Filleigh. It remained with the Fortescue family until it was sold in 1960. Until the seventeenth century Weare Giffard was the Fortescues' main residence, but it was then replaced by Castle Hill at Filleigh. The church at Weare Giffard contains several monuments to the family.

The fifteenth-century hall, now in private ownership, was built by the Fortescues. There is a splendid hammerbeam roof in the great hall. It was involved in fighting during the Civil War, when some walls were destroyed, but the gatehouse remains.

The bridge was built in 1815. Before that date the nearest bridges were at Torrington and Bideford, although Monkleigh could sometimes be reached by fording the river. The tolls for crossing the bridge were much resented, but it was not until 1907 that the bridge became free to use when a fête was held at Weare Giffard Hill to raise the final amount necessary. The bridge crosses the river close to

Annery limekilns. There are several limekilns along the Torridge, some of them quite elaborate and looking almost like miniature castles. Lying so close to the river, Weare Giffard is vulnerable to flooding and much work has been carried out to prevent this.

Above: Limekiln on the River Torridge by Weare Giffard.

Left: The Fortescue monument in Weare Giffard Church.

43. Frithelstock Church and Ruins of the Priory

'We came to the ruins of the Priory which tho' not grand nor extensive have a good deal of the Picturesque in them...' So wrote Revd John Swete when he visited in 1792, accompanying his words with a watercolour illustration. Since his time more of the ruins have disappeared, but they are the only remains of a religious house in North Devon. Founded about 1220 as a dependency of Hartland Abbey, the priory was surrendered in 1536 and the next year the priory and its lands were granted to Arthur Plantagenet, Viscount Lisle, and his wife Honor Grenville.

The visible remains are of the monastic church with three lancet windows high up in the west front. A slight mound marks the site of the high altar and earthworks in an adjoining field probably mark the site of the cloister. It was a small priory and by the fourteenth century there were clearly problems, as in 1340 Bishop Grandisson issued a long order for reform.

The parish church is next to the priory and has several interesting features, including several decorated bench ends dating from the late fifteenth or early sixteenth centuries. One of these depicts two heads of ecclesiastics facing each other with their tongues out, which may be a humorous reference to the dispute between

The ruins of Frithelstock Priory.

Above: Royal coat of arms from the reign of Charles II.

Left: Humorous decorated bench ends in Frithelstock Church.

the prior and the Bishop of Exeter. There is also a hart recalling the connection with Hartland Abbey. The earliest wall of the church is believed to be thirteenth century, although most of the building is fifteenth century or later. There is a large and impressive plasterwork royal coat of arms from the reign of Charles II. It is the work of John Abbott from the famous Abbott family of plasterers, who came from the parish. Hidden on a minor road in the hilly country between Bideford and Torrington, Frithelstock is worth a visit.

44. Clovelly

Clovelly is one of the best-known tourist attractions of North Devon, but it has to be included in the gems of North Devon because it is unique. To quote from the Devon edition of the *Buildings of England* series, 'The charm of the village is largely the intricacy of the overlapping of houses in all directions. It is quite beyond description.'

Those houses line one of the steepest, cobbled streets to be found anywhere, leading down to a small harbour, sheltered by a curved pier. The appearance of the village is due to the tight control exercised by the families who owned the area – first the Carys and later the Hamlyns. Many of the seemingly old cottages bear later date marks, often from the early twentieth century, attesting to repairs and alterations, but they

all contribute to the picturesque scene. The other factor in Clovelly's dramatic appearance is its situation surrounded by steep wooded hills going down to the sea.

Another unusual, if not unique, feature of Clovelly is that no cars are allowed on the cobbled street. Donkeys used to be employed as a means of transport, but now special sledges are used to move goods around the village.

George Cary built the pier in 1587, making it one of the few safe harbours on this coast and leading to the growth of the village. Clovelly has long been associated with herrings, or the 'silver darlings' as they were called. Records go back centuries and in 1749 there were around 100 herring boats in the harbour. Now there are only two herring fishermen, but Clovelly remembers its heritage with an annual Herring Festival in November.

As with many tourist destinations in North Devon, Charles Kingsley is partly responsible for the village's popularity as the Carys and Clovelly featured in *Westward Ho!* Charles Dickens also wrote about it in *A Message from the Sea*. The village has also featured in numerous paintings. J. M. W. Turner was one of the many artists who painted here.

A picturesque scene of beautiful Clovelly.

The steep path down to the harbour at Clovelly.

45. Clovelly Dykes

Just to the south of the village of Clovelly the site of Clovelly Dykes can be found. This Iron Age earthwork is situated on the high plateau behind the coast at approximately 210 metres above sea level. Although the terrain it sits in is flat, from the top of the high banks there are clear views of the Bristol Channel and Bideford Bay, making it of high strategic value. Unknown to many people in North Devon, Clovelly Dykes is considered one of the largest and most remarkable early Iron Age hill forts in the county.

The entire site, consisting of a series of complex earthworks, covers more than 20 acres. This particular type of earthwork is classified by experts as a 'concentric multi enclosure plateau hill fort'. The site is a massive enclosure and consists of concentric sub-rectangular enclosures with a smaller enclosure in the centre and further sections on the west side. Some banks have accompanying ditches and there are several identified entrances. The earthworks are unlikely to have been used for defence as the entrances are not the elaborate constructions seen on other defended hill forts, but are more simple constructions. The relatively slight banks

Aerial view of Clovelly Dykes.

seen in the internal enclosures also suggest an intended use as secure warehouses or stock pens. It is probable that the site was in use from the sixth century BC to the mid-first century AD.

Since 1946 there have been fairly regular aerial photographs taken of the site, which have added to the knowledge and understanding of how this hill fort developed and was used over its life. Large multivallate hill forts (those defined as having two or more defensive lines of earthworks) such as Clovelly Dyke are rare with only around fifty examples recorded nationally. Due to their comparative rarity all examples are considered to be of national importance.

46. Embury Beacon

Situated on a sheer west-facing cliff on the west of the Hartland Peninsula and to the west of Clovelly 150 metres above sea level sits Embury Beacon, the site of an Iron Age hill fort (*c.* 200 BC). Sadly, almost two-thirds of the site has been lost to coastal erosion over the last 2,000 years, but the remaining structures and buried deposits associated with it contain important archaeological and environmental information about its construction, use and how the site was adapted and reused over the following centuries. The location of this site is significant as it has panoramic views in all directions, both inland and across the Bristol Channel to Lundy, Wales and towards Tintagel Island. Owned by the National Trust, Embury Beacon is a listed Scheduled Monument.

Looking towards the Hartland Peninsula, the site of Embury Beacon.

Originally believed to have been built on land projecting out to sea, a detailed survey undertaken by the Royal Commission on the Historical Monuments of England in the 1990s suggested that it had more likely been surrounded by a coastal headland, most of which has eroded away over the last two millennia. Earlier excavations in 1972–73 found post holes, stake holes and two hearths, which are believed to indicate former roundhouses on the site. Distinctive South Western Decorated Ware dating to the late Iron Age was also found, together with a whetstone (a fine-grained stone used for sharpening cutting tools) and spindle whorls (used for cloth making), which also indicate domestic activity on the site.

Promontory forts such as Embury Beacon are regarded as settlements of high status that were probably permanently occupied. A recent programme of geophysical survey work carried out as part of the Unlocking Our Coastal Heritage project has led to more information being uncovered. Subsequent radiocarbon dating has shown that the outer earthworks were constructed and modified from the Iron Age through to the medieval period. Clearly there is much more research to be done to get a clear understanding of this amazing site.

47. Hartland Quay and Stoke Church

A few miles from Hartland Abbey is Hartland Quay and a coastline noted for some of the most dramatic cliffs in North Devon – indeed W. G. Hoskins in his classic history of Devon claimed that Hartland, 'contains the most impressive cliff scenery in England and Wales, above all the iron coast from Hartland Point southwards'. It was called the iron coast because of the extreme danger to shipping from the jagged cliffs with rocks extending outwards like fingers into the sea. The scene we see today is the result of incredible geological forces millions of years ago, when tectonic plates collided. Hartland means 'stag island', although it is a peninsula and the famous nineteenth-century parson Jack Russell enjoyed hunting here.

The quay was built in the reign of Henry VIII, but it was destroyed by storm damage in the late nineteenth century. The Old Customs House has been a hotel since 1886 and the former corn and hay lofts are now hotel bedrooms. The present slipway was constructed in 1970. This coast was extremely hazardous for shipping and there have been numerous shipwrecks. Between 1860 and 1900 there were fifteen wrecks. The Hartland Quay Museum provides information about the shipping around Hartland and the disasters. There are several coastal walks, details of which can be found at www.hartlandpeninsula.co.uk/walking. Like much of North Devon this sparsely inhabited peninsula is an Area of Outstanding Natural Beauty with a great deal of wildlife – some of it rare. Out in the water there are sometimes dolphins, seals and porpoises. Birds include puffins, peregrine falcons, oyster catchers and kestrels. Flowers include Devil's bit scabious, marsh orchid, bog violet and sea campion. It is also part of UNESCO's North Devon Biosphere.

A mile inland is St Nectan's Church, Hartland's parish church. Higher up than the abbey, its tower is the tallest in North Devon at 130 feet. It is visible from sea and was used as a guide by sailors. The original church was built around 1055, but the present building dates from 1360, although the font is late Norman work of approximately 1170. There are several wagon roofs, some ceilinged and some unceilinged. The rood screen of around 1470 is one of the finest in North Devon. There are numerous memorials, several connected with the families at Hartland Abbey, but also two plaques to John Lane and his adopted son Sir Allen Lane, who founded Penguin Books and whose family came from the area. One unusual item is the chair used by the exiled Ethiopian Emperor Haile Selassie at the official opening of the church fête in 1938, when he was staying at Hartland Abbey.

St Nectan is one of the early Celtic saints, which is unusual for a North Devon church. According to the legend, some robbers cut off his head and he laid it on a rock by the well before collapsing. According to legend, wherever a drop of blood fell a foxglove grew. The well can be seen nearby in a small wooded area with a stone well head.

Stoke Church at Hartland.

48. Hartland Abbey

Hartland Abbey is a hidden gem, deep in the remote countryside of the Hartland peninsula. In a narrow, wooded valley that runs down to the wild, dramatic and dangerous coast, the appearance of Hartland Abbey today is largely the result of eighteenth-century alterations, but its origins are much older.

The abbey was built in the twelfth century as a monastery of the regular canons of the order of St Augustine to serve St Nectan's Church at Stoke, which is Hartland's parish church. It remained a monastery until 1539 and was the last monastery to be dissolved by Henry VIII. The king gave the abbey to the sergeant of his wine cellar, William Abbott, and the property has never been sold, instead being inherited, with three heiresses bringing it to different families. In 1600, Catherine Abbott married Nicholas Luttrell of Dunster Castle and in 1704 Mary Luttrell married Paul Orchard. The third heiress was Anne Orchard, who married into the Stucley family. Her great-grandson, Sir George Stucley, moved into the property in 1845 and the Stucley family continue to live at the property. The house and gardens are regularly open to the public from March to October, as well as for various events.

The abbey was little altered until the eighteenth century when Paul Orchard and his son, another Paul, levelled the great hall, pulled down the abbey chapel and reduced the size of the main building to the level of the cloisters. Over that he built

Hartland Abbey, set in a narrow wooded valley.

The grounds of Hartland Abbey.

three reception rooms and bedrooms in the fashionable Georgian Gothic style, finally completing his scheme in 1779. Sir George Stucley decorated much of the house in Victorian style and in 1862 employed the famous architect Sir George Gilbert-Scott to design a new front hall and entrance. The result is that the abbey is a fascinating mixture of styles, reflecting its existence over 800 years. In the eighteenth-century drawing room, in 1845 Sir George Stucley added linenfold panelling, copied from the House of Lords, with murals painted above depicting historical events in which the Stucley family was involved. Sir George was also responsible for the vaulted and painted Alhambra Corridor, built to his instructions following his visit to the Alhambra Palace in Spain. Remarkably the fireplace in the billiard room is carved from stone brought from Malta in Sir George Stucley's yacht and landed at Hartland Quay before being carved on site. The rooms are filled with family paintings, furniture and china acquired through the centuries.

There are also vast numbers of documents relating to the property and, although some have been deposited in the Records Office and the British Museum, several are on display at the abbey.

Hartland Abbey is a fascinating place and, as well as the grounds and gardens, there is also a pleasant short walk along the valley to the coast at Blackpool Mill, where there is a lonely cottage. It is possible many visitors will recognise this cottage as it has appeared on television and in films, including in 2007 the BBC adaption of Jane Austen's *Sense and Sensibility*. An episode of *Antiques Roadshow* was also filmed at the abbey a few years ago, as well as other films.

49. Lundy

Lundy (not Lundy island – the name means 'puffin island' in old Norse and is mentioned in the twelfth-century *Orkneyinga Saga*) is visible from most parts of the North Devon coastline and is around 22 miles north-west of Instow. It is around 3 miles long and half a mile wide and is predominantly granite, with slate at the southern end. It is possibly the centre to an old volcano and was originally connected to the mainland at Baggy Point, but broke away in the last ice age. Archaeological evidence indicates that it was occupied in prehistoric times.

For a small island it has had a surprisingly turbulent history, being used as a base by pirates and rebels. In the mid-eighteenth century it was leased by the notorious Barnstaple MP Thomas Benson, merchant and smuggler. He acquired the contract to transport criminals overseas, but diverted them to Lundy where he used them

Lundy from the coast near Hartland.

Before the last Ice Age, Lundy was connected to Baggy Point.

as slave labour. In the nineteenth century it was sometimes called 'the Kingdom of Heaven' when it was bought by W. H. Heaven, who claimed it was a 'free island' and resisted the jurisdiction of the mainland magistrates. In fact, it is part of the county of Devon.

In modern times it has become well known for its wildlife, which still includes puffins, although their numbers are much reduced. The seas around Lundy are a Marine Protected Area to safeguard the marine life, including grey seals and the underwater scenery. The island is now owned by the National Trust, but managed by the Landmark Trust, who have twenty-three holiday cottages on Lundy. In summer the MS *Oldenburg* runs regular day trips from Bideford or Ilfracombe, which allow time to explore the island. St Helen's Church, built by Rev Hudson Heaven to replace a disused earlier chapel, had fallen into disrepair, but has recently been restored. Now called St Helen's Centre, it includes space for education, research and study.

50. South West Coast Path

North Devon has been described as a walker's paradise with so many different landscapes to enjoy, from picturesque villages, river valleys, woodland and dramatic cliffs. However, for those with an interest in geology and a wish to experience the impressive and rocky coastline with its far-reaching coastal views, the North Devon section of the South West Coast Path, which covers roughly 85 miles, has to be unbeatable.

The geology of this coastline is fascinating and, in parts, world renowned. The geological story of the region is complex and one of the most varied in the British Isles. Several hundred million years ago the area was part of a vast ocean basin and as the landscape changed, shales, slates and sandstones formed. These date from the

The rugged cliffs on the South West Coast Path.

Stunning scenery of the coast path.

Carboniferous period and can be seen in the cliffs at Hartland Quay. The zig-zag formation pattern is clearly visible. Devon was the centre of massive geological activity during this period, which created much of the dramatic rocky coastline we have today. The rocks were twisted and contorted by intense heat and pressure, creating unique rock formations. There are many places along the coast path where you can see evidence of this.

Anyone who has experienced the coast path has their favourites walks, but for the purposes of this book, three can be particularly recommended. The first is from Croyde to Baggy Point, which is ideal for beautiful panoramic views looking towards Bideford and Hartland – a fairly easy walk that has an alternative return path. The second walk to be recommended is Lee Bay and Bull Point Lighthouse. The walk starts and ends in the picture postcard village of Lee (famous for its fuchsia bushes) and covers just 4 miles. There are some glorious sea views and the lighthouse is

Looking down onto a hidden cove on the coast path.

a fascinating landmark. Finally, Lynmouth to Combe Martin, a longer walk of just over 13 miles. On this walk you will see the highest sea cliff in England. At 318 metres high, Great Hangman is truly spectacular. The walk begins in Lynmouth and heads west through the Valley of the Rocks, past Woody Bay, onto Great Hangman and down to Combe Martin, where the walker can finally relax in one of the old pubs along the front.

Bibliography

Bradbeer, J., and T. Green, *The Heritage Handbook: An A-Z Guide to the Archaeology and Landscape History of Northern Devon* (Museum of Barnstaple and North Devon)
Cherry, B., and N. Pevsner, *The Buildings of England: Devon* (London: Penguin Books, 1989)
Christie, Peter, *Secret Bideford* (Stroud: Amberley Publishing, 2016)
Holton, D. and E. Hammett, *Barnstaple & Around: The Postcard Collection* (Stroud: Amberley Publishing, 2016)
Hoskins, W. G., *Devon* (Newton Abbot: David & Charles, 1954)
Mayo, Ronald, *The Story of Westward Ho!* (Yelland: Ronald Mayo)
Owen, the Revd Prebendary T. R., *St Brannock's Church, Braunton* (The Church Publishers, Margate)

Online Sources

www.britishnewspaperarchives.co.uk
www.hartlandpeninsula.co.uk
www.nationaltrust.org.uk
www.tarkatrail.org.uk
www.torringtoncommon.co.uk